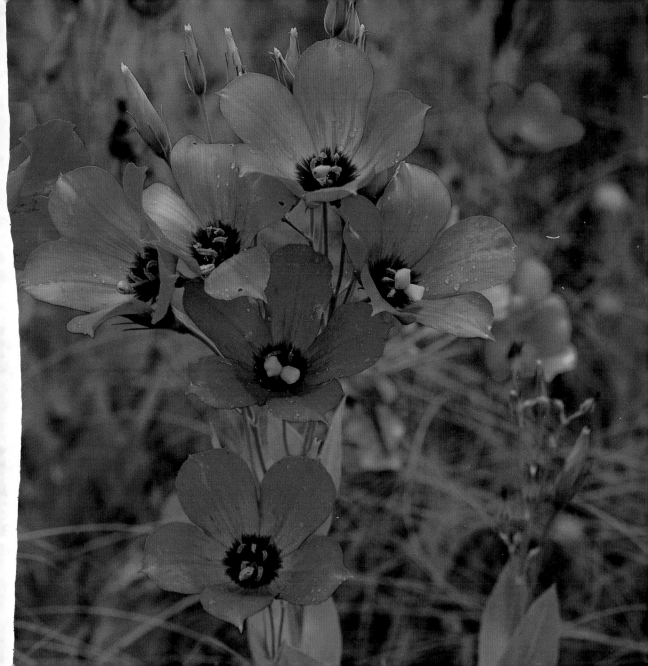

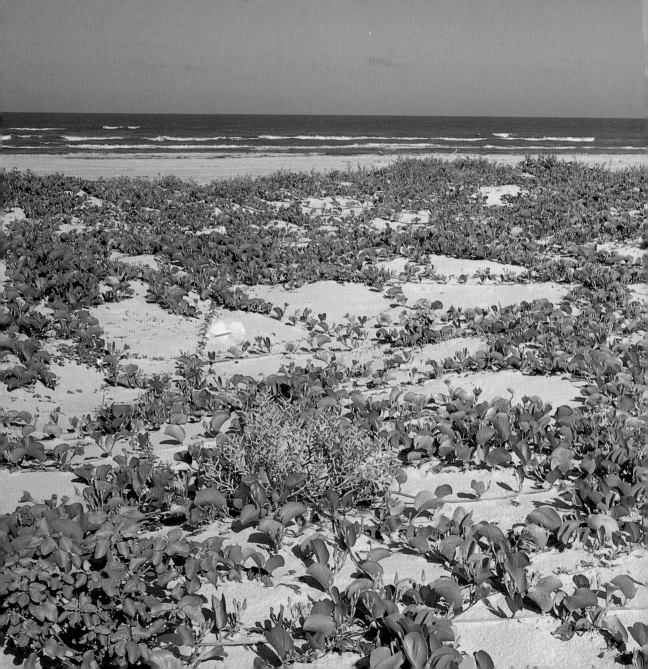

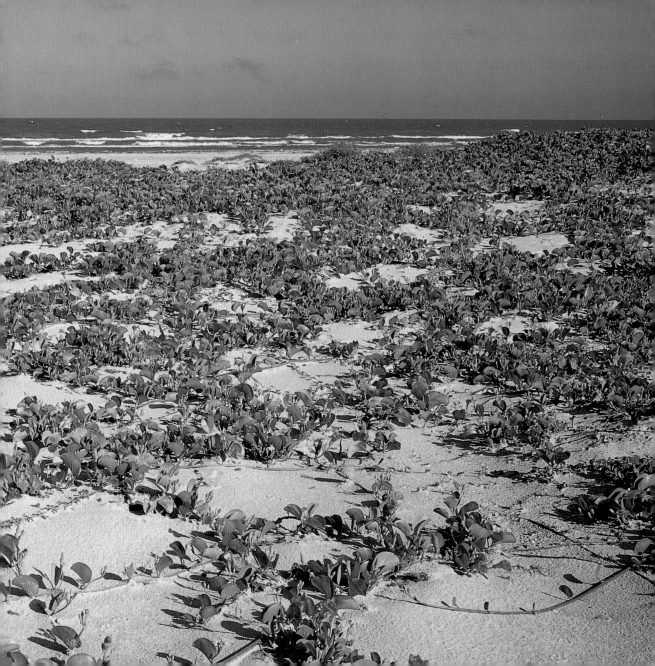

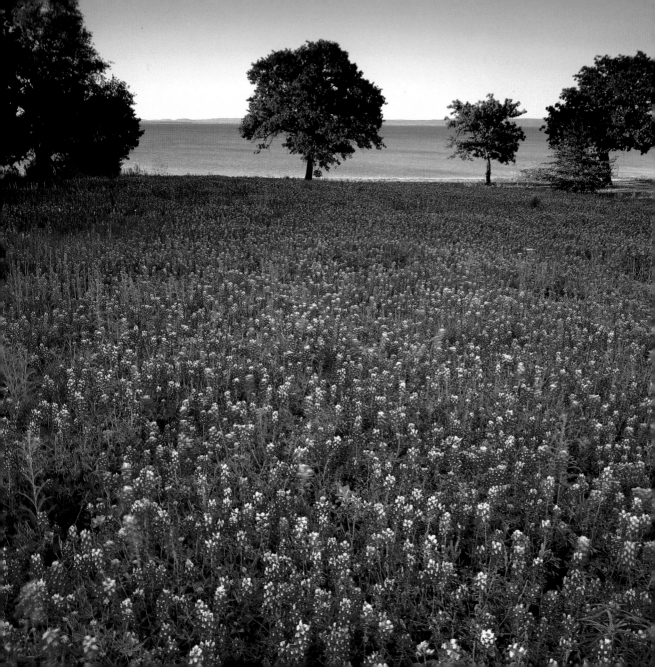

TEXAS WILDFLOWERS

Photography by Richard Reynolds
With Selected Prose & Poetry

Texas Littlebooks

Englewood, Colorado

First frontispiece: Bluebell gentian, Blanco County
Second frontispiece: Railroad vine, Padre Island National Seashore
Third frontispiece: Bluebonnets and Indian paintbrush, near Lake Buchanan, Llano County
Opposite: Wildflowers, Palo Duro Canyon State Park

International Standard Book Number: 1-56579-143-6
Library of Congress Catalog Number: 95-62424
Copyright Richard Reynolds, 1996. All rights reserved.
Published by Westcliffe Publishers, Inc.
2650 South Zuni Street, Englewood, Colorado 80110
Publisher, John Fielder; Editor, Suzanne Venino; Designer, Amy Duenkel
Printed in Hong Kong by Palace Press

Quotes on pages 14, 20, 24, 50, and 58 are from the book *Adventures with a Texas
Naturalist* by Roy Bedichek © 1947, 1961, renewed 1989.
Courtesy of the University of Texas Press

For more information about other fine books and calendars from Westcliffe Publishers,
please contact your local bookstore or contact us by calling (303) 935-0900,
faxing (303) 935-0903, or writing us for a free color catalogue.

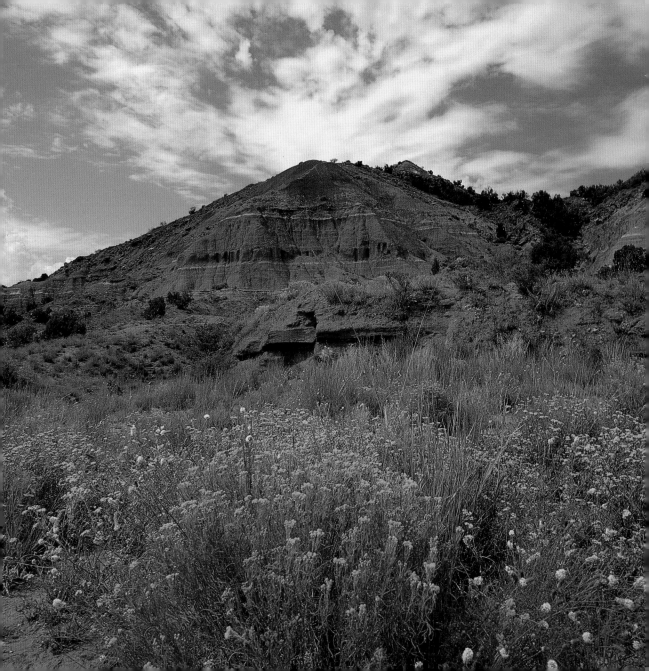

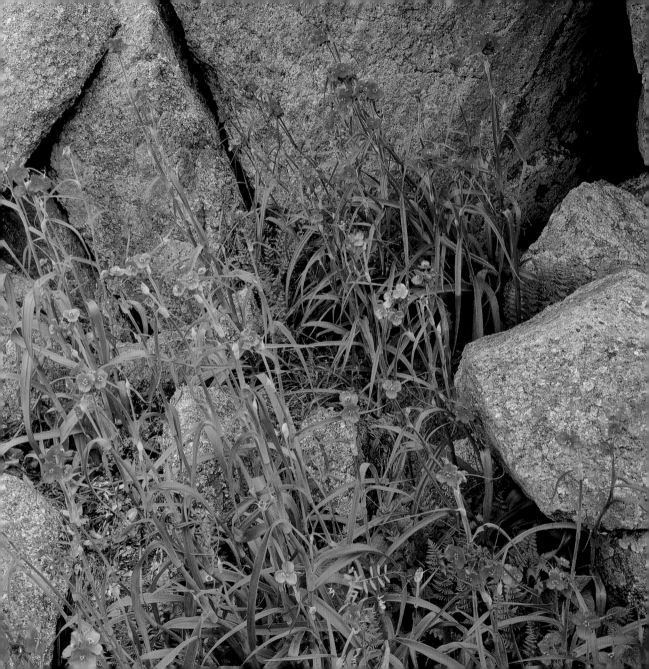

PREFACE

They are at once the most difficult and the most rewarding things to photograph. They are the most unpredictable and most elusive, but perhaps the most spectacular and beautiful of Texas' many natural treasures. They are wildflowers, and no state in the Union can boast more of them, in diversity of species or in sheer numbers.

It has been estimated that there are more than 5,000 species of wildflowers in Texas. They grow at the highest elevations of the Guadalupe Mountains, as well as near sea level on Padre Island. They thrive in the arid climes of the Trans-Pecos, where rainfall averages less than ten inches a year, as well as in humid southeast Texas, which normally sees as much as sixty inches.

By far, the best-known of Texas flowers is the bluebonnet. There are actually six distinct species of *Lupinus* in Texas, all of which are considered to be the official state flower. They grow in almost every part of the state, thanks to the seeding efforts of the state highway department over the past fifty years. The most numerous of bluebonnets is *Lupinus texensis*, which form vast seas of flowers around the Highland Lakes region of Central Texas from mid-March through April.

The names given to Texas wildflowers are often as colorful as the flowers themselves. Some are derived from animals (cow vine, dog cactus, antelope horns, and snake cotton), as well as from humans (old man's beard, granny's nightcap, widow's tears, and lady's slipper). There are delicate names (baby blue-eyes, thimbleflower, angel trumpets, and pink windmills), and dangerous ones (cancer weed, death camas, crow poison, tread softly, and skullcap). Some almost whet the appetite (duck potato, scrambled eggs, and butter daisy) and some don't (greasewood, bloodroot, and locoweed).

Being a self-confessed wildflower nut, I routinely drive five to six thousand miles each

Spiderwort, Enchanted Rock State Natural Area

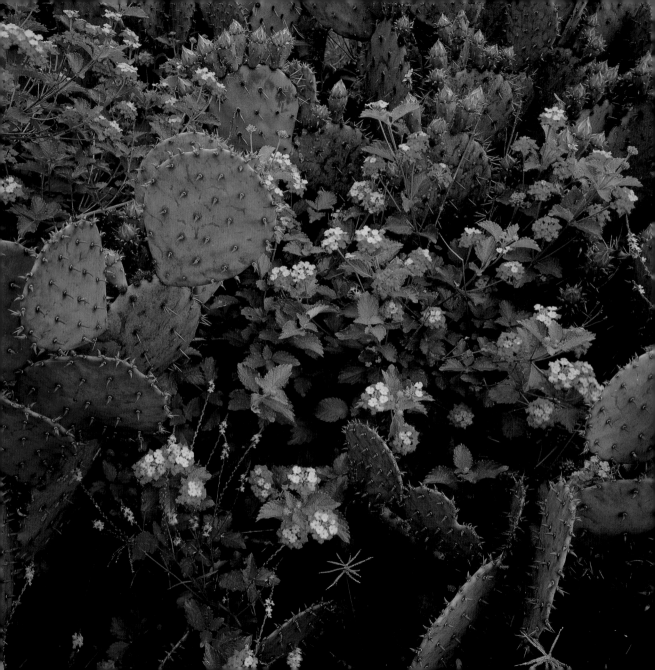

spring to find the best wildflowers. One can never be sure where the best displays will be, as there are many complex factors that go into creating a good bloom.

In March 1994, I was driving one of my usual Highland Lakes routes near Lake Buchanan northwest of Austin when I happened upon the most spectacular, densely packed bluebonnet field I have ever seen. A few well-placed, crimson Indian paintbrush flowers provided accent color for the field of bluebonnets, which stretched unbroken over an area I estimated to be several hundred meters on each side. I decided to photograph the scene around dusk, because I knew the full moon would be rising right after sunset, and I wanted it in the photograph.

All the elements came together that evening: the winds abated after sunset (to allow for a long exposure in the dim light), there was a strong afterglow in the sky behind me, and the beautiful, full moon rose exactly when and where I thought it would. And all this happened in a year that was not supposed to have a good bloom because of insufficient fall and winter rains.

The following autumn, the rains were ideal for an excellent germination, and I anticipated a spectacular bloom in the spring. Imagine my surprise and consternation when I returned to that field in early April to find, at most, a quarter as many bluebonnets than were there the previous year! What vagaries of nature were responsible for this unexplainable flip-flop of conventional scientific wisdom? At that point, I vowed to get out of the wildflower prediction business and just accept what blooms or doesn't bloom each spring.

I hope that the photographs in this book will never become a mere record of the way Texas once was. I also hope that those viewing these images will be inspired to see these Texas treasures for themselves — and come to the realization that the natural world is an inseparable part of the human spirit.

—Richard Reynolds
Austin, Texas

Yellow lantana, vervain, and prickly pear cactus, Frio County

"Spring lightens the green stalk, from thence the leaves

More aerie, last the bright consummate flower."

— John Milton, *Paradise Lost*

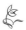

Spider lilies, Colorado County

"I walked a mile stretch of highway on a May afternoon, listing every flower I could find. At the mile's end I found that I had listed sixty-eight species."

— Roy Bedichek, *Adventures with a Texas Naturalist*

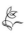

Bluebonnets, phlox, and Fendler's bladderpod,
Gonzales County

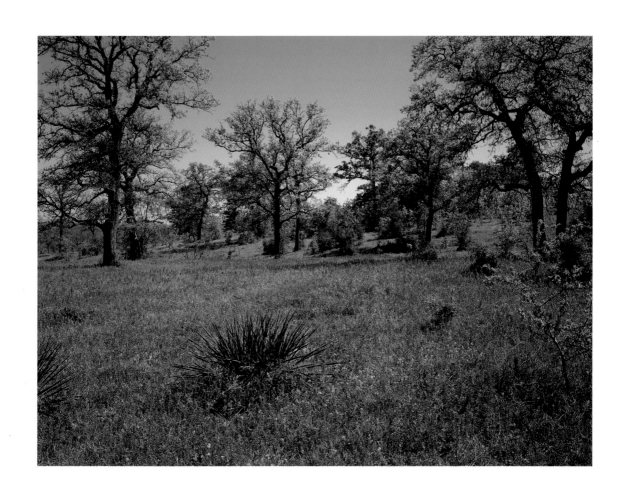

"You must not know too much, or be too precise or
scientific about birds and trees and flowers...
a certain free margin...helps your enjoyment
of these things."

— Walt Whitman, *Specimen Days*

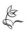

Downy paintbrush, Coleman County

"Nothing is so like a soul as a bee. It goes from
flower to flower as a soul from star to star,
and it gathers honey as a soul gathers light."

— Victor Hugo, *Ninety-Three*

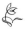

Huisache tree, Real County

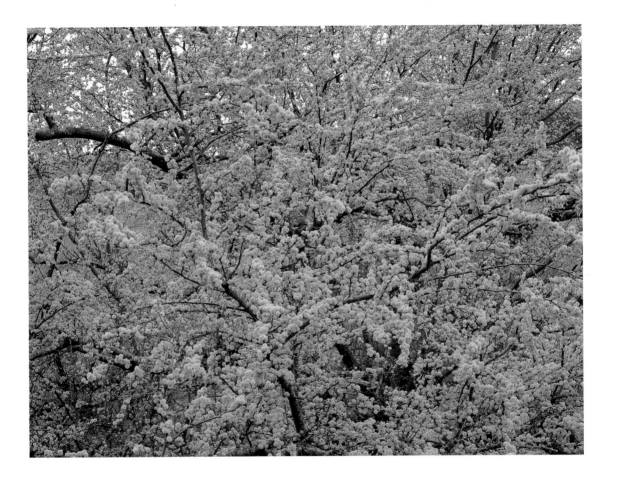

"It does seem to be a miracle that from the bones of tiny organisms deposited millions of years ago on the floor of an ancient sea there should now arise to greet the sun a little flower marked by such ingenious and beautiful workmanship."

— Roy Bedichek, *Adventures with a Texas Naturalist*

Claret cup cactus in the Chisos Mountains,
Big Bend National Park

Overleaf: Evening primroses, Atascosa County

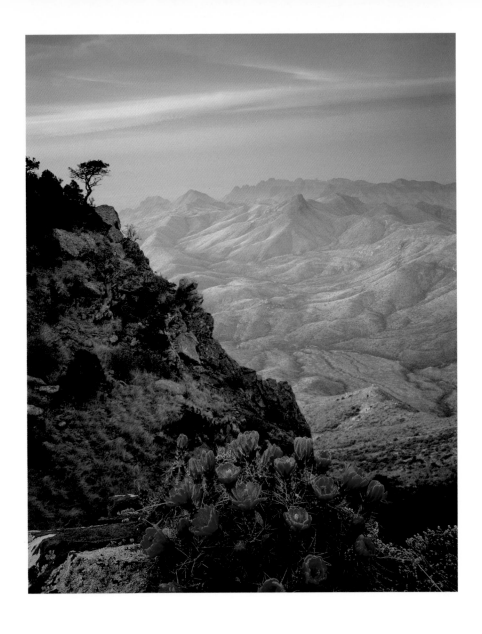

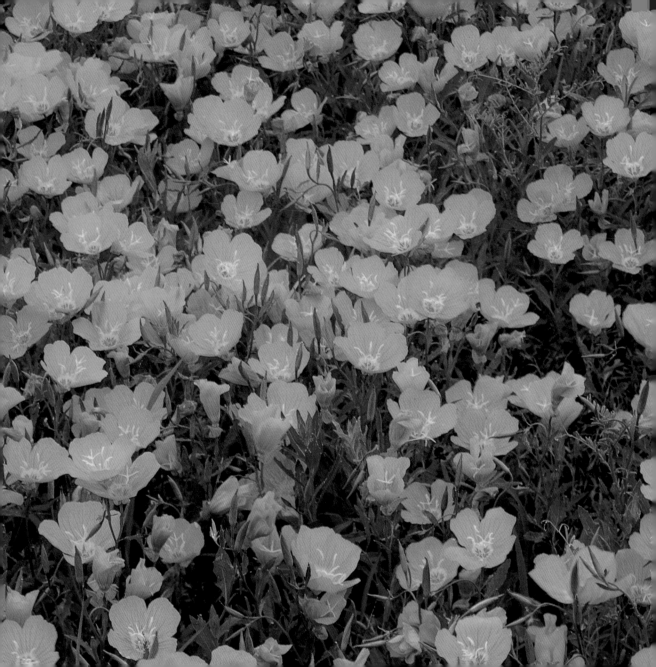

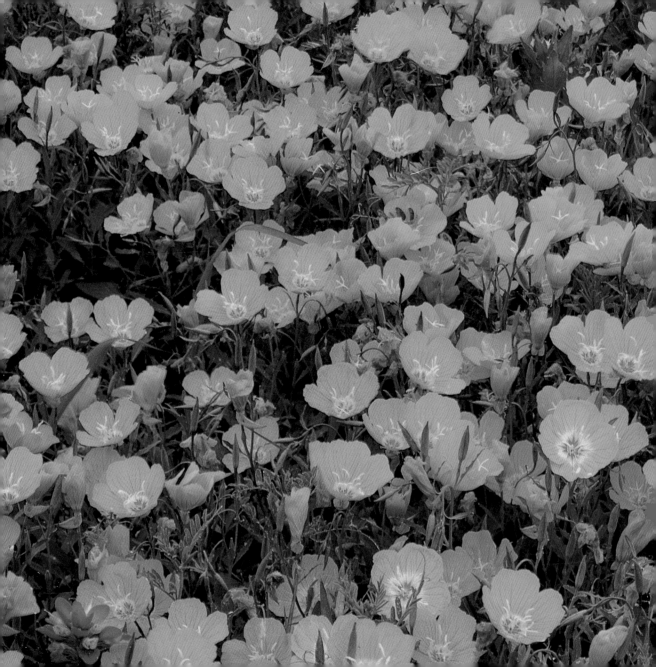

"Flowering dogwood in East Texas against
the gloomy green of a bank of pines a quarter of a mile
away delights the eye..."

— Roy Bedichek, *Adventures with a Texas Naturalist*

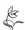

Dogwood blossoms, Harrison County

"How does the meadow-flower its bloom unfold?

Because the lovely little flower is free

Down to its root, and, in that freedom bold."

— William Wordsworth,
A Poet! He Hath Put His Heart to School

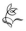

Field of dandelions, bluebonnets, and phlox, Atascosa County

"The earth laughs in flowers."

— Ralph Waldo Emerson, *Hamatreya*

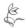

Prairie verbena and gaillardia, Llano County

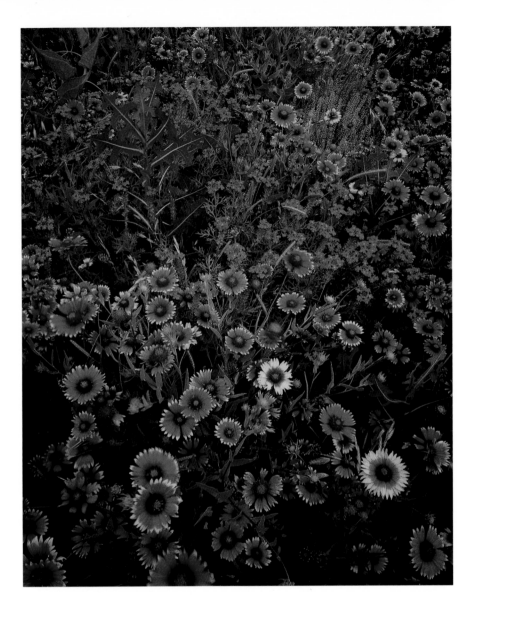

"A charm that has bound me with the witching power,

For mine is the old belief,

That midst your sweets and midst your bloom,

There's a soul in every leaf!"

— Maturin Murray Ballou, *Flowers*

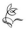

American lotus, Caddo Lake, Harrison County

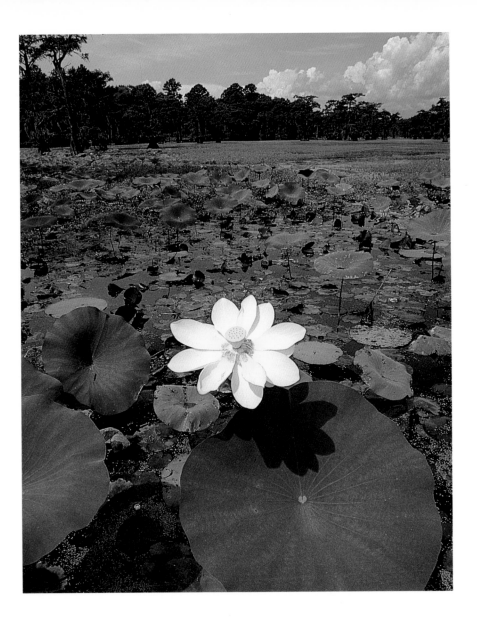

"The loveliest flowers the closest cling to earth..."

— John Keble, *Spring Showers*

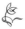

Lace cactus, Inks Lake State Park, Burnet County

"Beauty is its own excuse for being."

— Ralph Waldo Emerson, *The Rhodora*

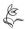

Basket flowers, Palo Duro Canyon State Park

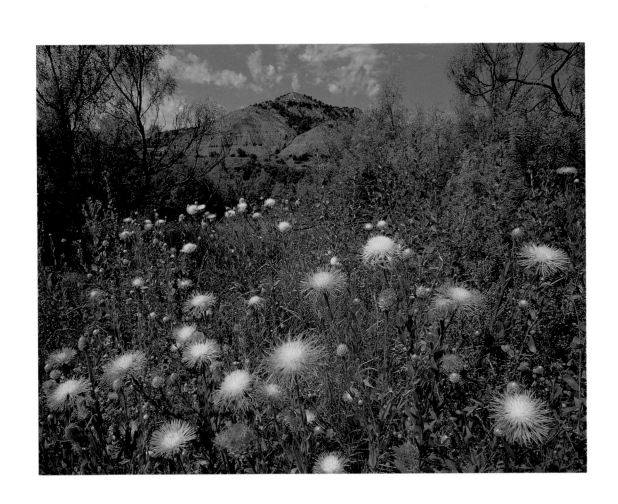

"Nothing in the world is single,

All things by law divine

In one spirit meet and mingle."

— Percy Bysshe Shelley, *Love's Philosophy*

Bluebonnets and Drummond's phlox, Gonzales County

Overleaf: Prickly poppies and bluebonnets, Gillespie County

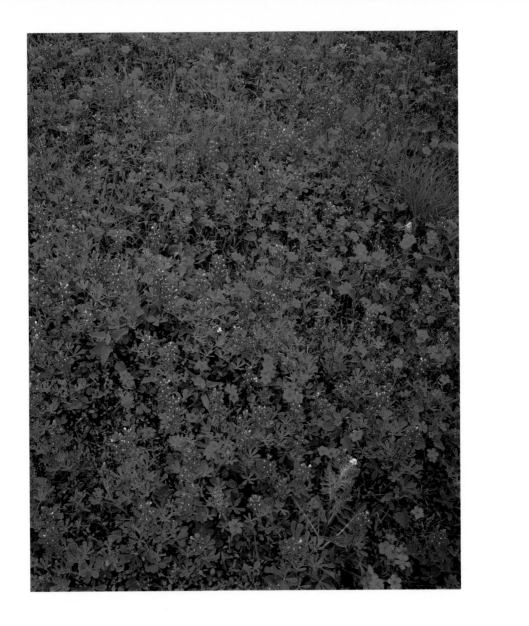

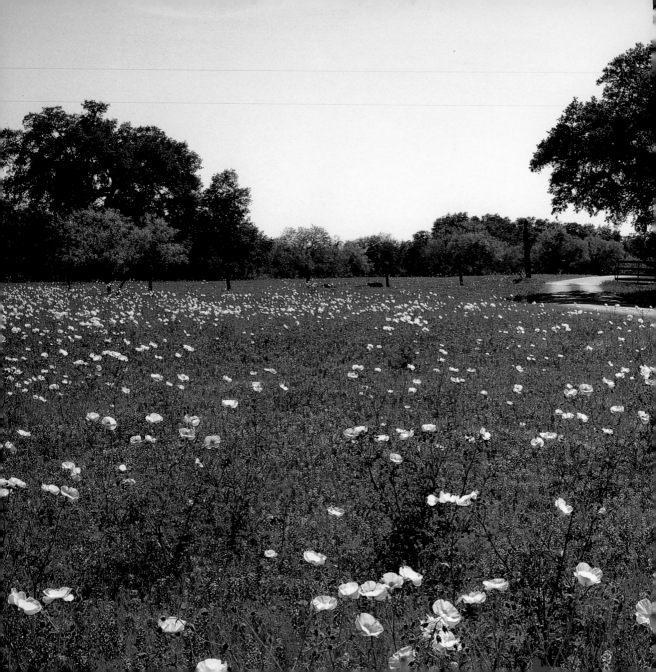

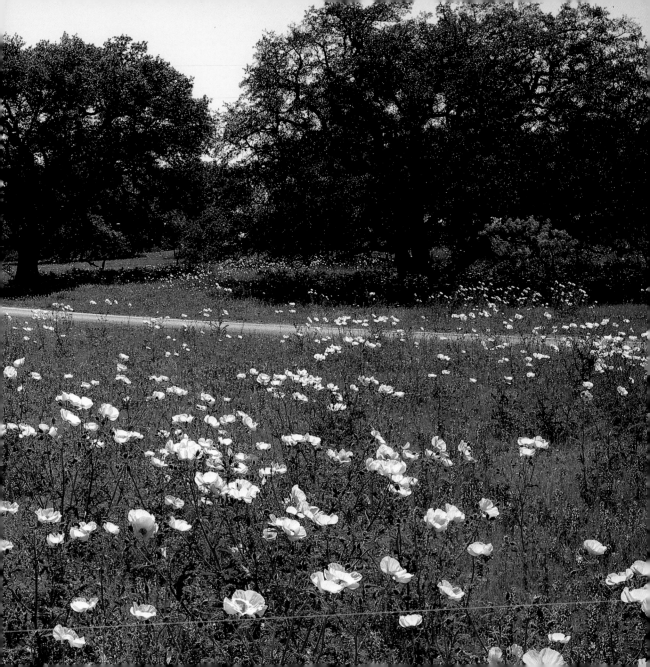

"Beauty is truth, truth beauty—

that is all

Ye know on earth,

and all ye need to know."

— John Keats, *Ode to a Grecian Urn*

Purple prickly pear in bloom, Big Bend National Park

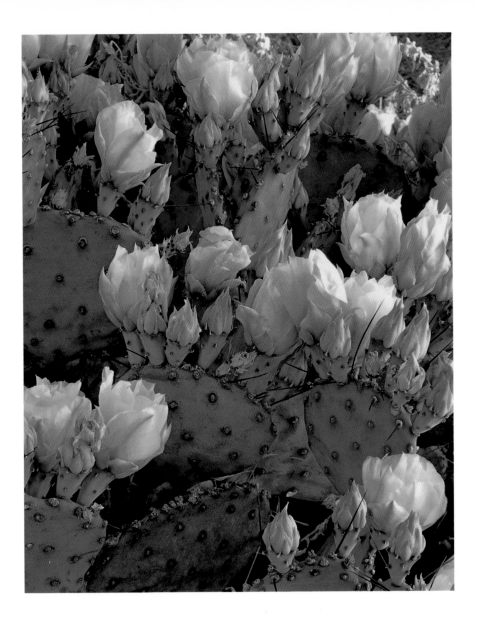

"And 'tis my faith, that every flower

enjoys the air it breathes."

— William Wordsworth, *Lines Written in Early Spring*

Railroad vines, Padre Island National Seashore

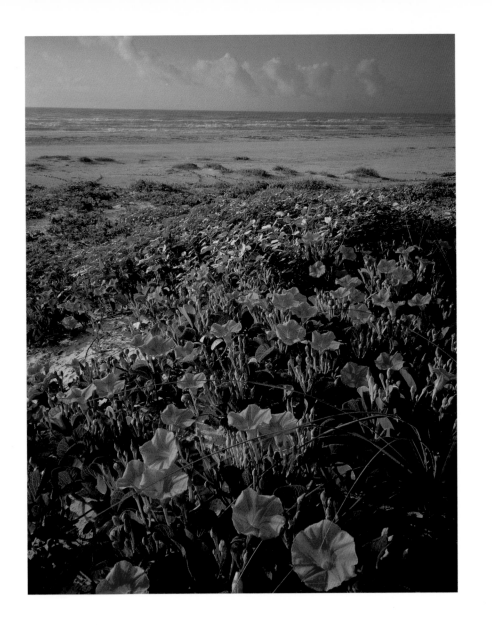

"I should like to enjoy this summer
flower by flower."

— Andre Gide, *Journals*

Drummond's phlox and bluebonnets, Gonzales County

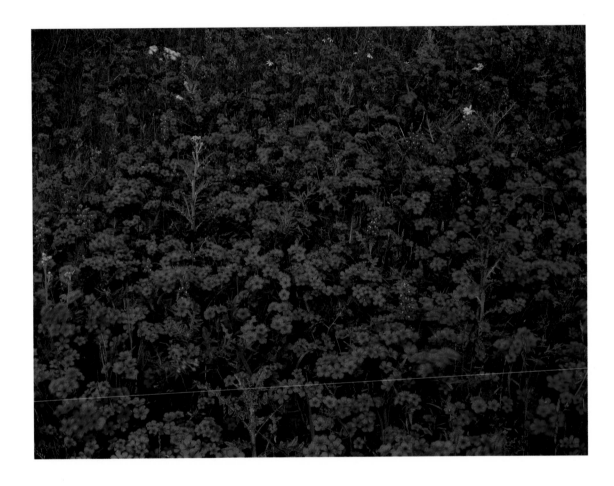

"Flowers...are like lipstick on a woman — it just
makes you look better to have a little color."

— Lady Bird Johnson,
Time magazine, September 5, 1989

Antelope horns and gaillardia, McCulloch County

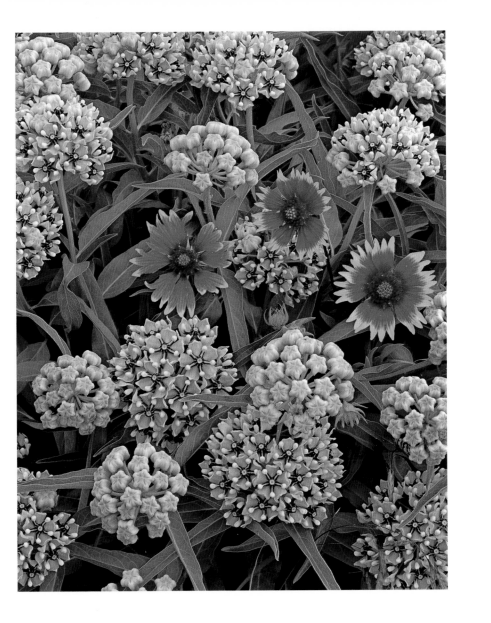

"Flowers have expression of countenance
as much as men or animals. Some seem to smile;
some have a sad expression; some are pensive and diffident;
others again are plain, honest and upright..."

— Henry Ward Beecher, *Star Papers: A Discourse of Flowers*

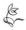

Blue-curl flowers, Big Bend National Park

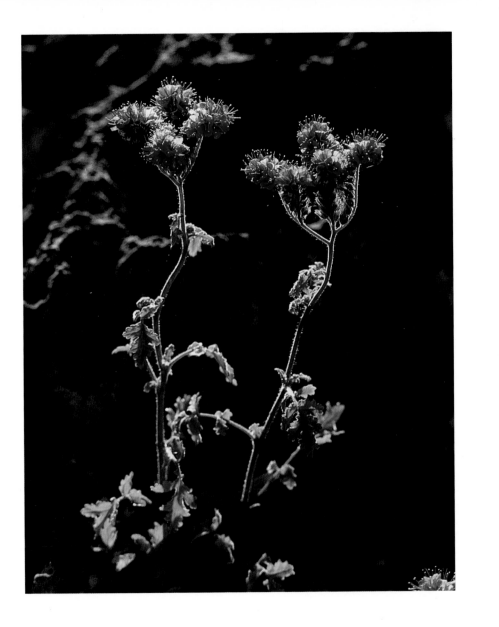

"Judging from the native vegetation growing on an adjacent highway,
there were no less than a hundred different species
of flowering plants and shrubs, as well as a dozen different grasses
thriving here before the pasture land was intensively grazed,
the field was fenced, and the first plow
disturbed its long-accumulated humus."

— Roy Bedichek, *Adventures with a Texas Naturalist*

Cattle graze among bluebonnets, Washington County

"Flowers are words

Which even a baby may understand."

— Arthur C. Coxe, *The Singing of Birds*

Blossom of horse-crippler cactus, Big Bend National Park

Overleaf: Baby blue-eyes, phlox, and large-flowered buttercup, Gonzales County

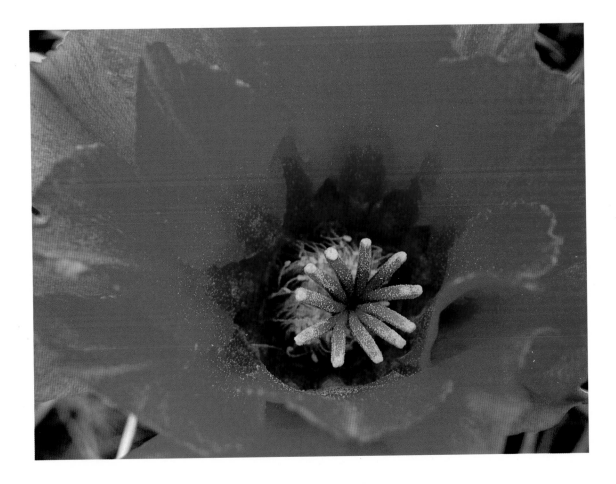

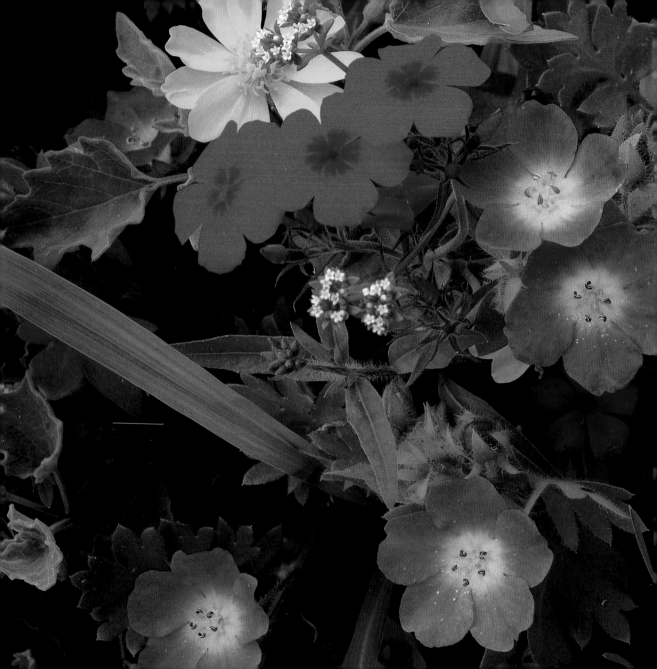

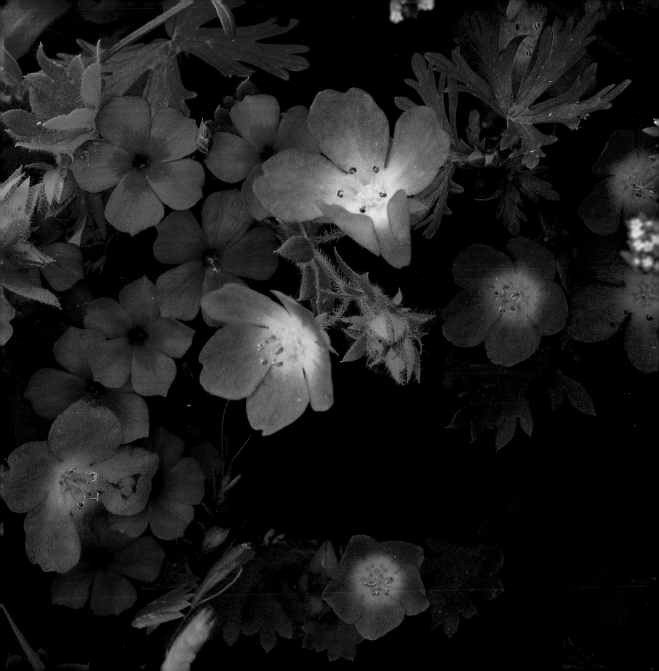

"Beauty is a primeval phenomenon, which itself never makes its appearance, but the reflection of which is visible in a thousand different utterances of the creative mind, and is as various as nature herself."

— Goethe, from Eckermann's *Conversations*

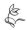

Field of bluebonnets and Indian paintbrush, De Witt County

"Some flowers under heavy grazing bloom low and by stealth
as if they knew the doom of those who hold their heads up
and go about the business of blooming and seeding
as normal vegetables do. They learn to hug the ground,
or sneak through the grass and
play hide-and-go-seek with the grazing beast."

— Roy Bedichek, *Adventures with a Texas Naturalist*

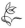

Prickly pear cactus in bloom, Big Bend National Park

"Throw hither all your quaint enamell'd eyes

That on the green turf suck the honied showers,

And purple all the ground with vernal flowers."

— John Milton, *Lycidas*

Bluebonnets, phlox, and groundsel, Wilson County

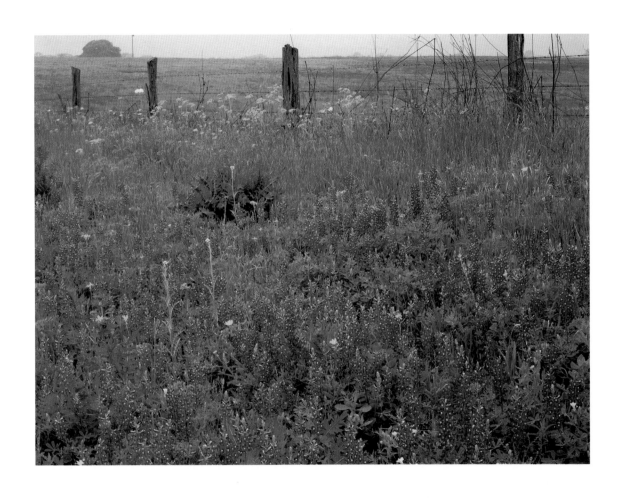

"The Amen! of Nature is always a flower."

— Oliver Wendell Holmes,
The Autocrat of the Breakfast-Table

Coreopsis and gaillardia, Lyndon B. Johnson State Park

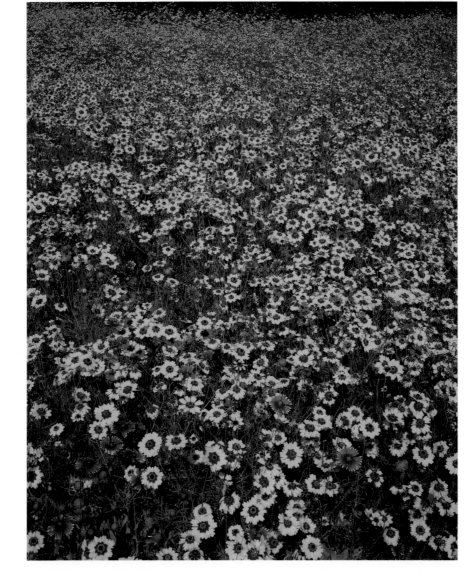

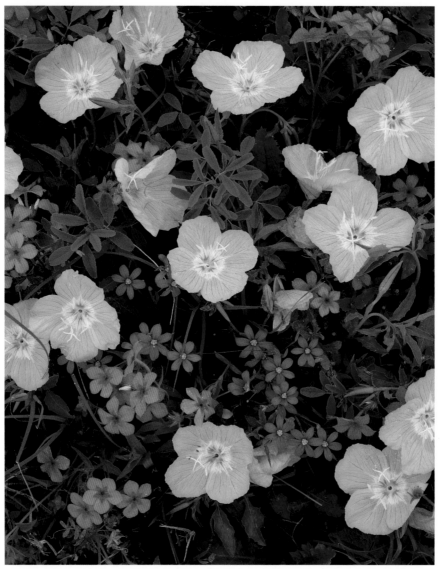

Blue-eyed grass, phlox, and pink evening primrose, Wilson County